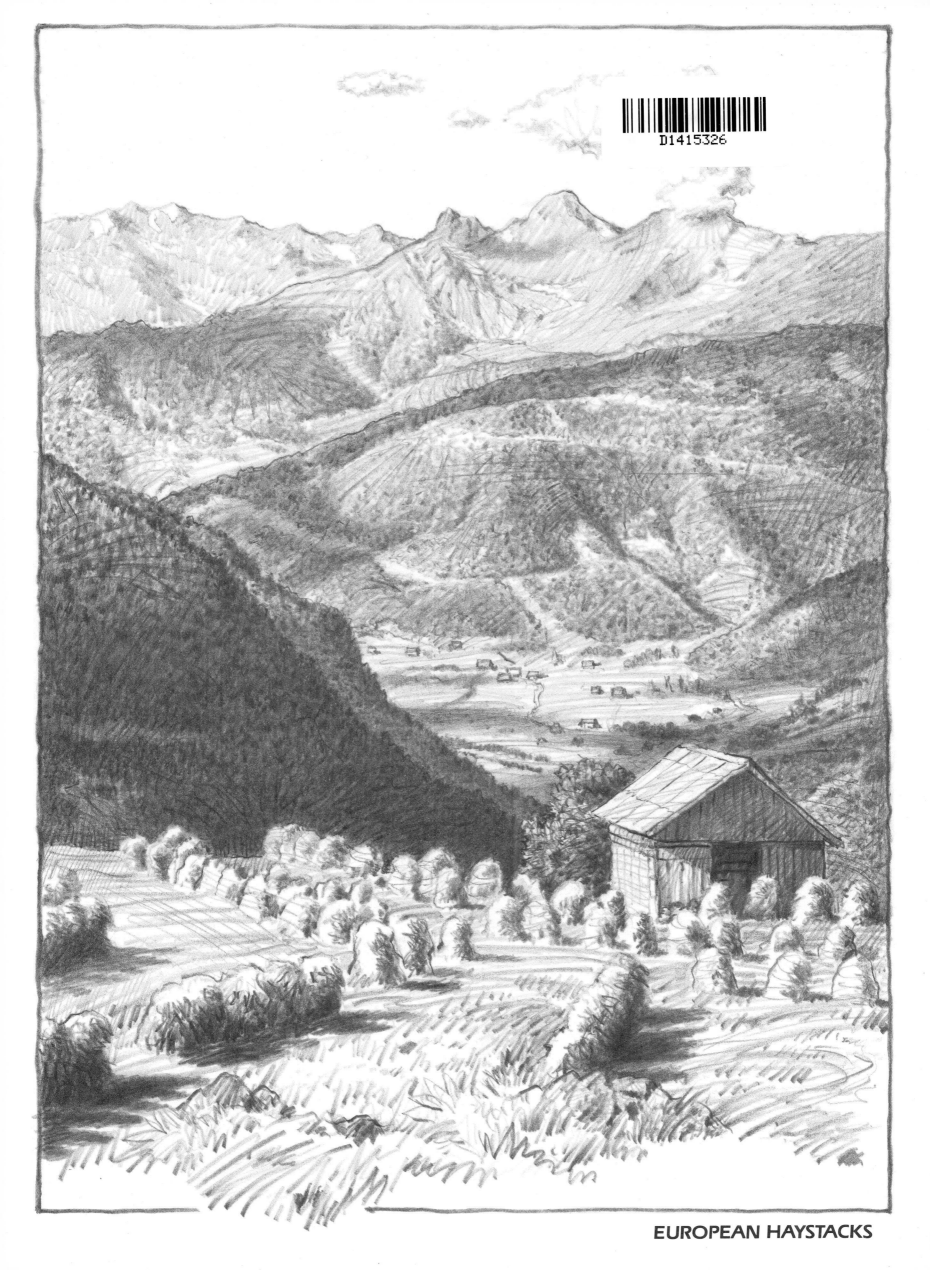

EUROPEAN HAYSTACKS

1

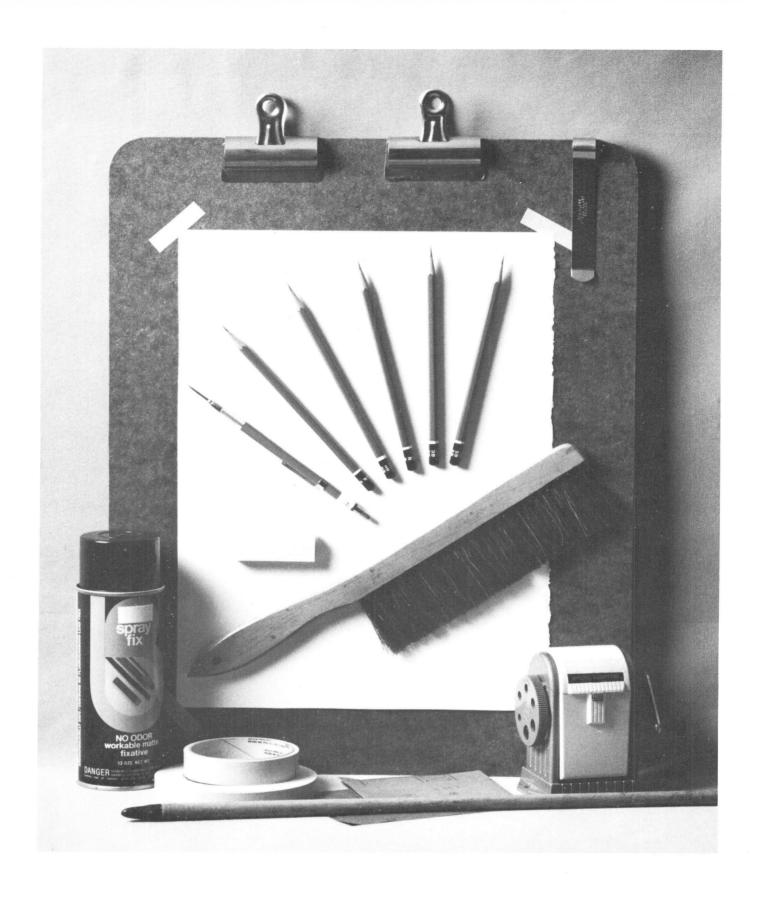

SUPPLIES NEEDED

PENCILS

I use both wooden pencils and metal drafting pencils in this book. The ones I recommend to begin with are:

Wooden Pencils

Hard ⟵ F HB B 3B 5B ⟶ Soft

Drafting Pencil

Metal holder and H lead, for roughing in.

PAPER

I prefer a smooth, textureless paper because I can avoid grain and build my own texture. I use 50% cotton, Italian, 140 lb., neutral pH, hot-pressed paper available in 22" x 30" sheets. Plate finish papers sold in pads are also acceptable.

ACCESSORIES

A smooth **drawing board** of ¼" tempered masonite or plexiglass, size 16" x 20"; **masking tape** or **clips** for attaching paper to your board; a **vinyl eraser** (I use vinyl exclusively to avoid damaging the paper); **maulstick**; sheet of **plain bond paper** to slip under the hand while working to avoid smudging; **desk broom**, to brush off debris; **pencil sharpener**, as pictured; **#220 and #600 sandpaper** for forming lead points; **workable fixative**, available in a spray can. Several light coats are sprayed on the finished drawing to prevent smudging.

PENCIL PROCEDURE

INTRODUCTION

Once you are acquainted with the tools and how to prepare and maintain them, and have practiced the value scale, the pencil strokes, and the shading samples on the following pages, then you are ready to begin the four steps that lead to accomplished pencil drawings. You will need to spend considerable time practicing each step. This faithful practice will bring great results in your final drawings. So plant your feet firmly and dig in for a determined effort in mastering this self-development program of pencil drawing.

STEP ONE — ROUGHING IN

Rough in the subject with an "H" lead and metal holder; the holder laid flat and held under your hand. Allow lots of freedom in your strokes, moving your entire arm. At this point think only about general shapes. You will add definition and detail later. Practice this step again and again.

STEP TWO — LINE DRAWING

You will need to invest time and practice to develop an expressive line drawing. Use the point of an "H" or "F" lead or wooden pencil.* Experiment with holding the instrument in both writing and underhand positions. In the underhand position, you can vary the thickness of your line by rolling the lead or pencil on its side for thick lines or up on the point for thin. Train yourself to show roundness and depth with expressive lines.

STEP THREE — PRELIMINARY SHADING

To achieve successful shading you must establish the structural pattern smoothly and under careful control. Gently "lay in" the darks and shadows in medium tones. Don't commit yourself too darkly, too soon. Once you are sure, darken these areas by pressing harder or switching to a softer pencil. Allow the point to become slick and smooth for even tones.

STEP FOUR — FINISH

For final shading, use a somewhat darker pencil, drawing on a smooth point for even tonal control. Repeat the shading process over and over with softer pencils until you achieve your desired density. Reinforce the lines and accents as you go. Add final action strokes for the ultimate artistic effect.

Focus your attention on each finished drawing in this book, observing the detail, and use the other steps only for reference. Afterwards, concentrate on your own personal handling of the pencil.

To avoid smudging, spray the completed drawing with several light coats of workable fixative. (If you immediately frame the drawing under glass, you do not need to spray.)

Sometimes you may want to create a complete drawing using only one hardness of pencil. "HB" is a good average pencil for this purpose. You may want to start with three HB pencils, one at each degree of sharpness. By varying the pressure on the pencil points and changing hand positions, you can accomplish several values and a wide variety of strokes.

***Note:** Throughout the book, "lead" means a metal drafting holder with removeable lead; "pencil" refers to a wooden pencil.

PENCIL POINTS

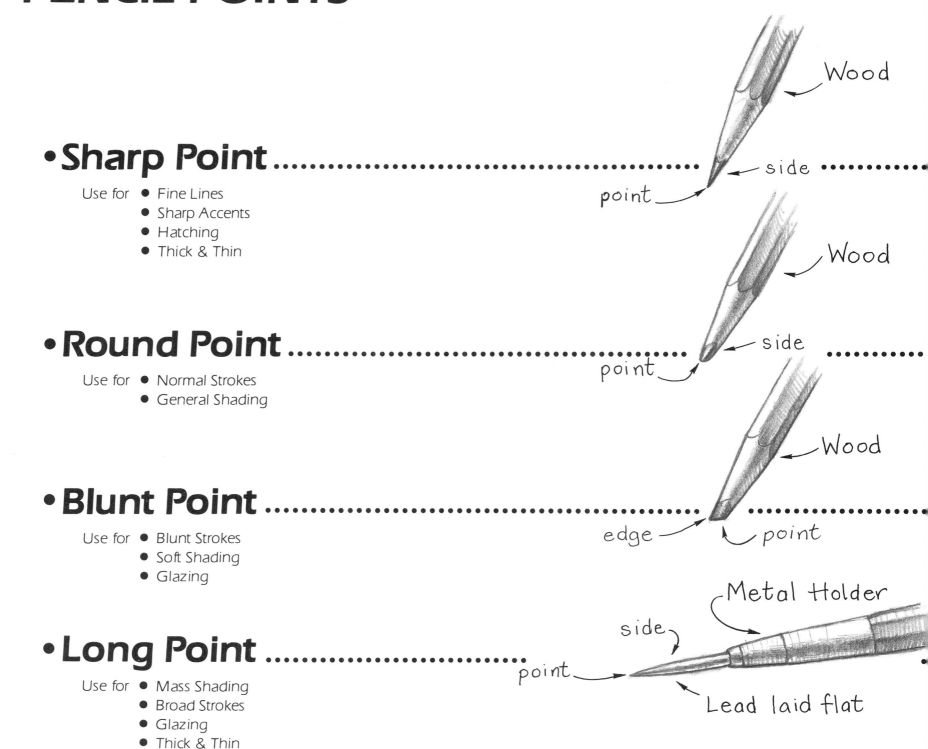

• Sharp Point

Use for
- Fine Lines
- Sharp Accents
- Hatching
- Thick & Thin

Wood

point — side

• Round Point

Use for
- Normal Strokes
- General Shading

Wood

point — side

• Blunt Point

Use for
- Blunt Strokes
- Soft Shading
- Glazing

Wood

edge — point

• Long Point

Use for
- Mass Shading
- Broad Strokes
- Glazing
- Thick & Thin

Metal Holder

side

point

Lead laid flat

SHARPENING

Wooden Pencil

You may use either an electric or manual sharpener for wooden pencils. After sharpening, rub the point on a paper towel to clean and smooth. The ball and blunt points are produced by brief use. While working, I keep several pencils with each type of point close at hand.

Metal Holder With Removable Leads

With about ½" of lead extended, I form the point on #240 sandpaper, then finish and polish it with #600 sandpaper to a long point as shown above.

PENCIL STROKES

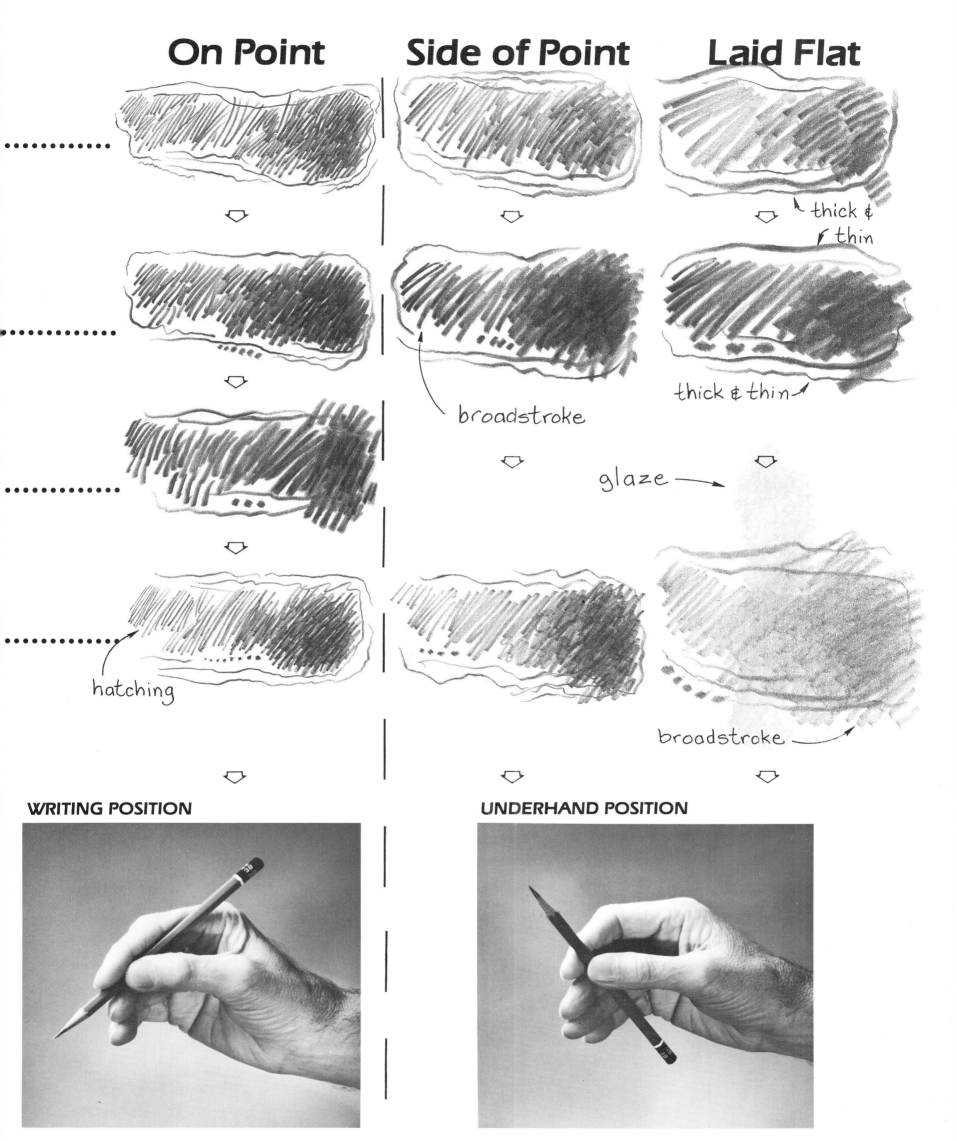

On Point Side of Point Laid Flat

thick & thin

broadstroke

thick & thin

glaze

hatching

broadstroke

WRITING POSITION

UNDERHAND POSITION

VALUE SCALE

Tones

1.

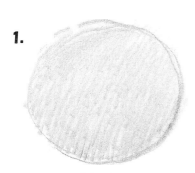

Light

2.

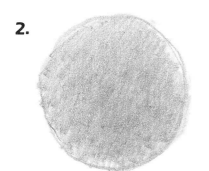

Medium Light

3.

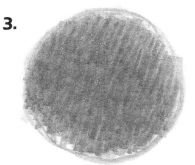

Medium

4.

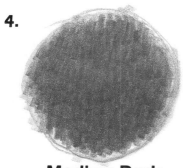

Medium Dark

5.

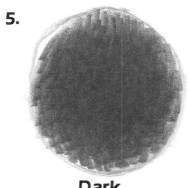

Dark

Transition of Tone

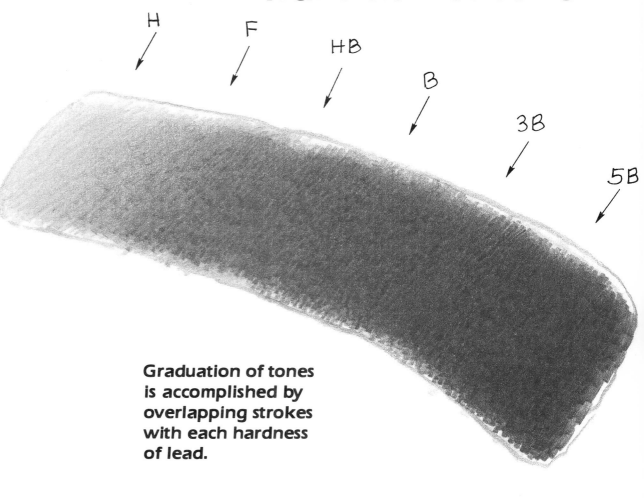

Graduation of tones is accomplished by overlapping strokes with each hardness of lead.

Shown here are five of the nine tones in the value scale. These five are all you will really need, even for advanced drawing. Practice these five tones as a musician might practice the musical scale — over and over. When the tones are firmly planted in your mind, you will be able to achieve the most refined shading effects. When you know instinctively how to hold and handle each pencil, you will be able to execute each tone with assurance.

As you gradually master the value scale you will increasingly possess the ability to turn ordinary drawings into works of great substance and depth.

SHADING SAMPLES

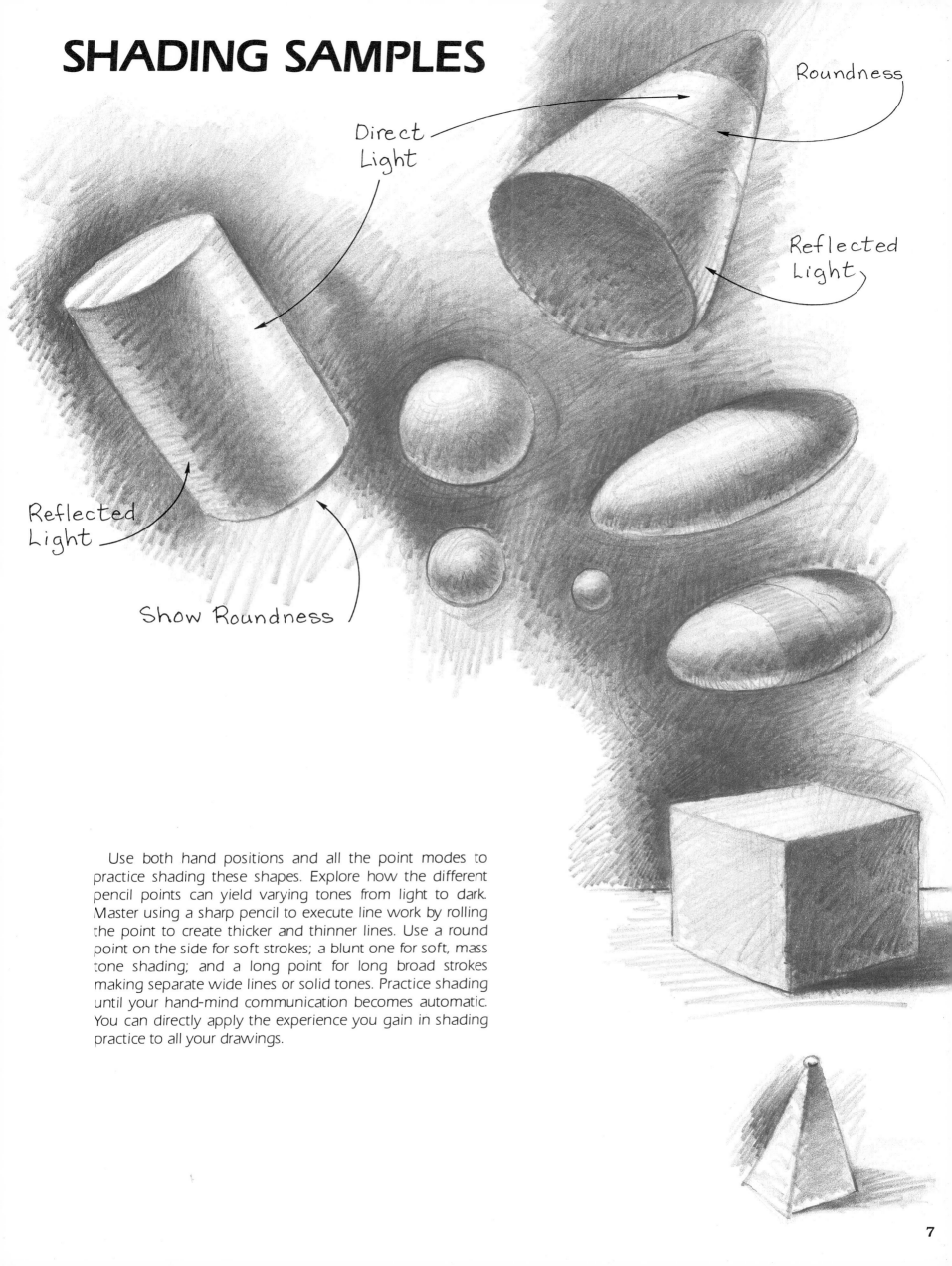

Direct Light

Roundness

Reflected Light

Reflected Light

Show Roundness

Use both hand positions and all the point modes to practice shading these shapes. Explore how the different pencil points can yield varying tones from light to dark. Master using a sharp pencil to execute line work by rolling the point to create thicker and thinner lines. Use a round point on the side for soft strokes; a blunt one for soft, mass tone shading; and a long point for long broad strokes making separate wide lines or solid tones. Practice shading until your hand-mind communication becomes automatic. You can directly apply the experience you gain in shading practice to all your drawings.

THUMBNAIL

KEY TO VISUALIZATION

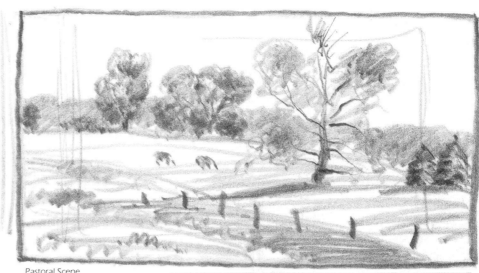

Pastoral Scene

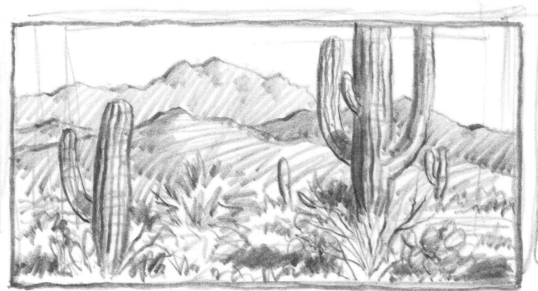

Southwest Desert

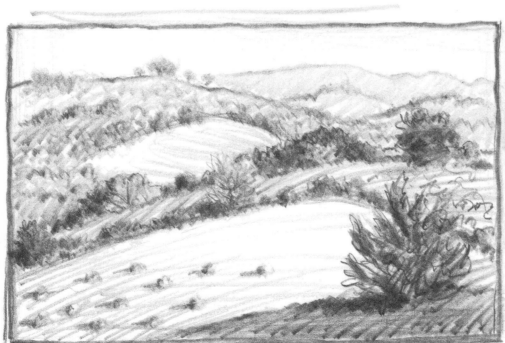

Rolling Hills

The use of small "thumbnail," or brief, concise sketches is a good way to get your ideas on paper and to develop your compositions before beginning a finished drawing. You can move elements such as rocks and trees into various positions until you find one that pleases you. Do several sketches before deciding on the final composition for your piece. These sketches are quick, easy, and a lot of fun!

SKETCHING

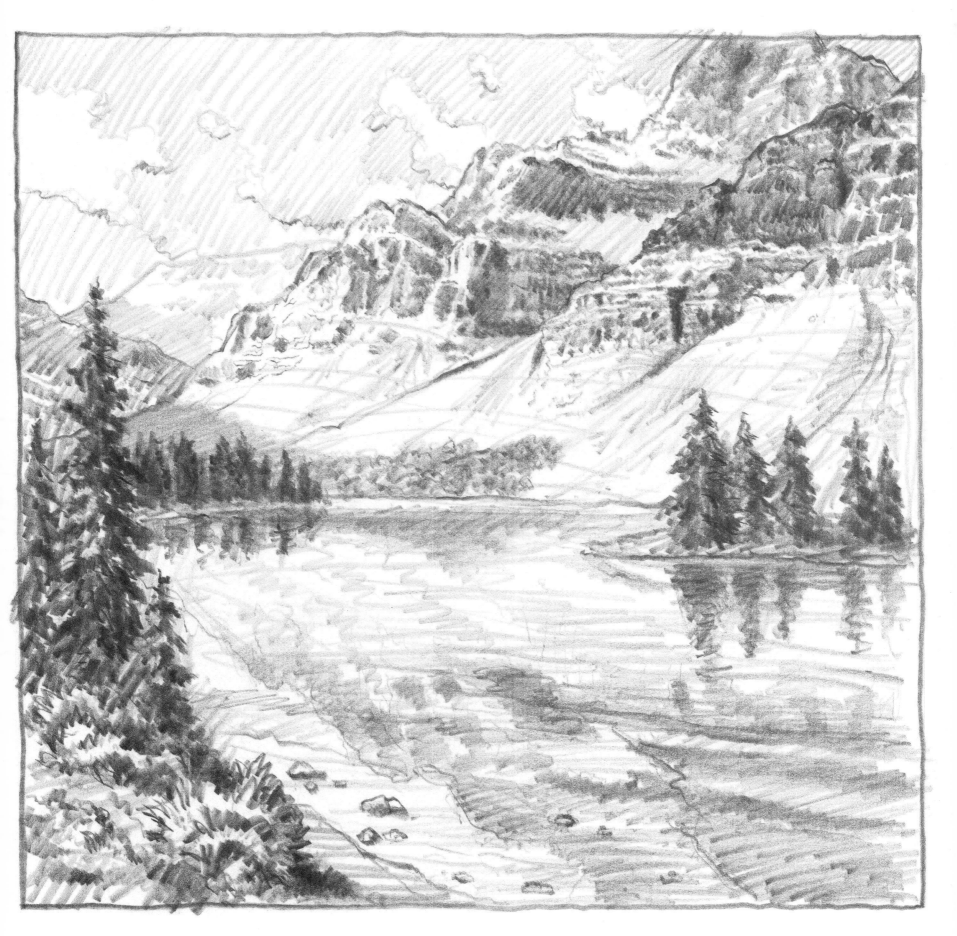

WHY SKETCH?

Sketching is a shorthand form of drawing. This quick and easy way of getting ideas down on paper is an important part of the training program for art students.

The benefits received from this basic practice are numerous. Sketching develops your mind's eye and your hand coordination. It is a way of making a clearer visual study of the things around you. The sketches can be used as study ideas for finished paintings or drawings. As you form the habit of sketching, you will have fun and be rewarded in other ways, too. You will be programmed as a learned draftsman — a necessary element in becoming a truly competent artist. It is a fulfilling experience to be able to draw what you see!

COMPOSITION

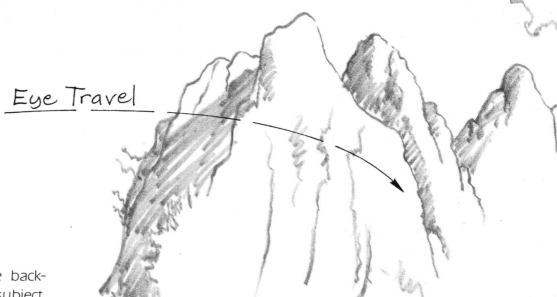

Eye Travel

BACKGROUND . . .

. . . The distant part of a landscape.

Depending on the composition, the background may be just a setting for the main subject, or it may be used to show great distance. The background may be composed of clouds, trees, mountains, rocks, or any element of nature. Here, the mountains are the background. They also happen to be the center of interest. They catch the eye, move it from left to right, and lead the viewer down into the picture.

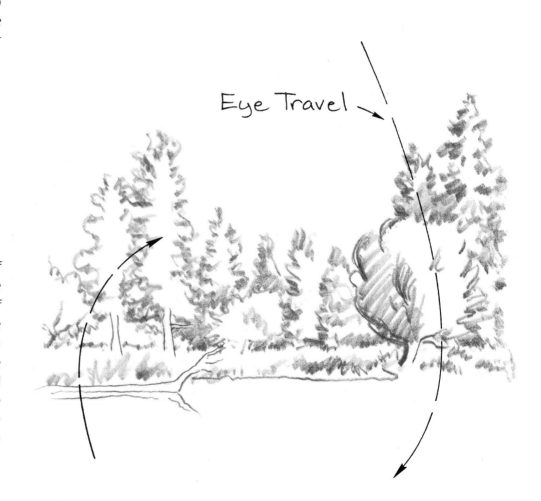

Eye Travel

MIDDLE GROUND . . .

. . . The space in between.

The middle ground is usually made up of things that help tie the objects in the front to the shapes in the back. But, sometimes the center of interest is located in the middle ground, with the close objects used to complement the main subject, and the background arranged to set off the center of interest. In this picture, the middle ground is serving to tie the picture together and move the eye to the foreground. The incidental objects, like grass and brush, make the prominent objects, like the trees and mountains, stand out.

FOREGROUND . . .

. . . The part of a scene nearest the viewer.

Objects in the foreground are usually used to help direct the viewer's eye to the main subject. These objects can be in deep shadow to create depth and contrast, or well-lit to stand out against the middle and background elements. Here, the eye moves from the round tree in the middle ground to the old snag and rocks in the foreground. It then continues left and up into the picture again.

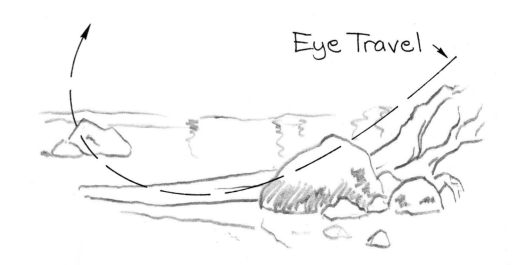

Eye Travel

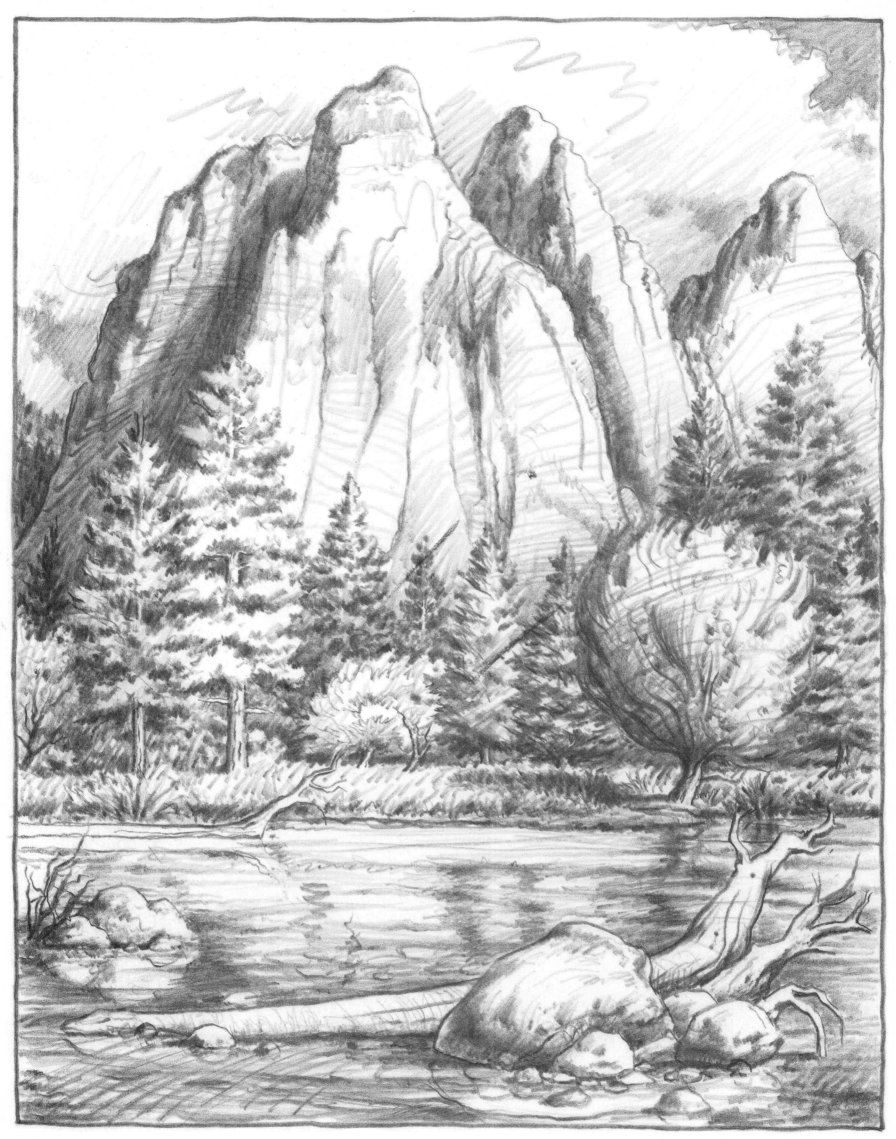

It is important that each part of a landscape be artfully arranged to insure good eye travel. Proper composition will move the eye from shape to shape as the mind processes the visual information.

CLOSE-UPS

...HOLLYHOCKS

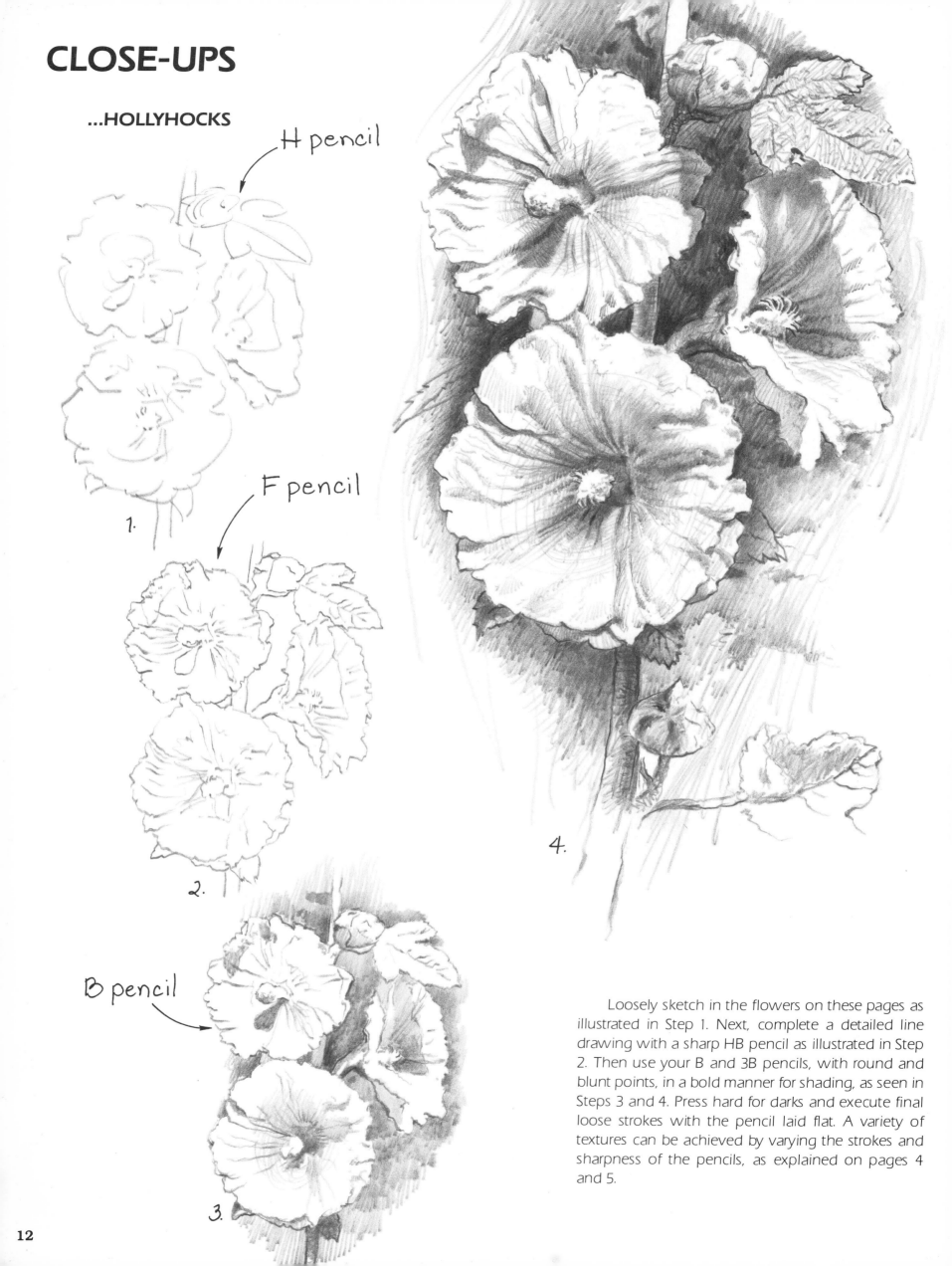

H pencil

1.

F pencil

2.

B pencil

3.

4.

Loosely sketch in the flowers on these pages as illustrated in Step 1. Next, complete a detailed line drawing with a sharp HB pencil as illustrated in Step 2. Then use your B and 3B pencils, with round and blunt points, in a bold manner for shading, as seen in Steps 3 and 4. Press hard for darks and execute final loose strokes with the pencil laid flat. A variety of textures can be achieved by varying the strokes and sharpness of the pencils, as explained on pages 4 and 5.

...SUNFLOWER

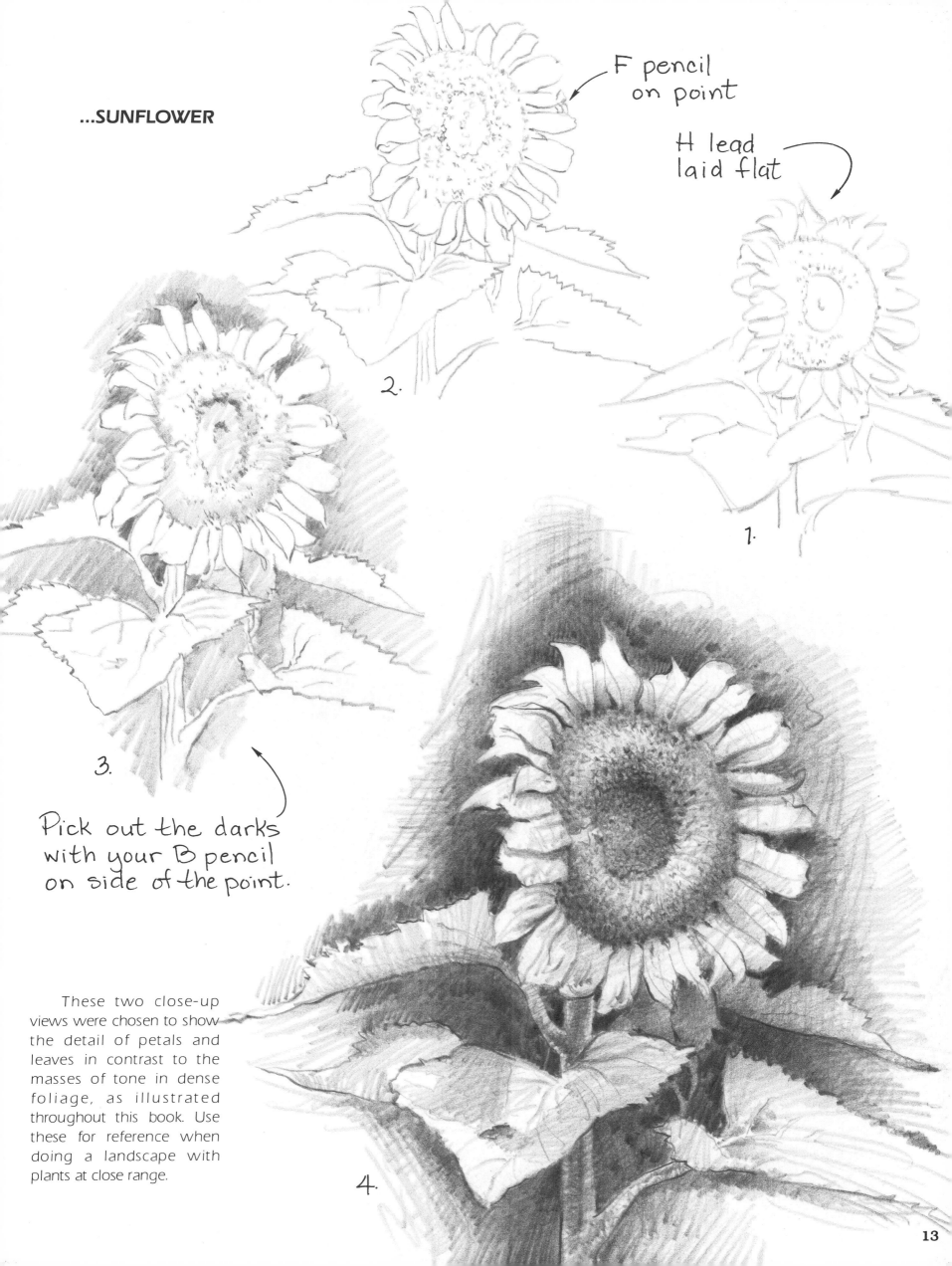

F pencil
on point

H lead
laid flat

2.

1.

3.

Pick out the darks
with your B pencil
on side of the point.

These two close-up views were chosen to show the detail of petals and leaves in contrast to the masses of tone in dense foliage, as illustrated throughout this book. Use these for reference when doing a landscape with plants at close range.

4.

ROCK STUDY

H lead
laid flat.

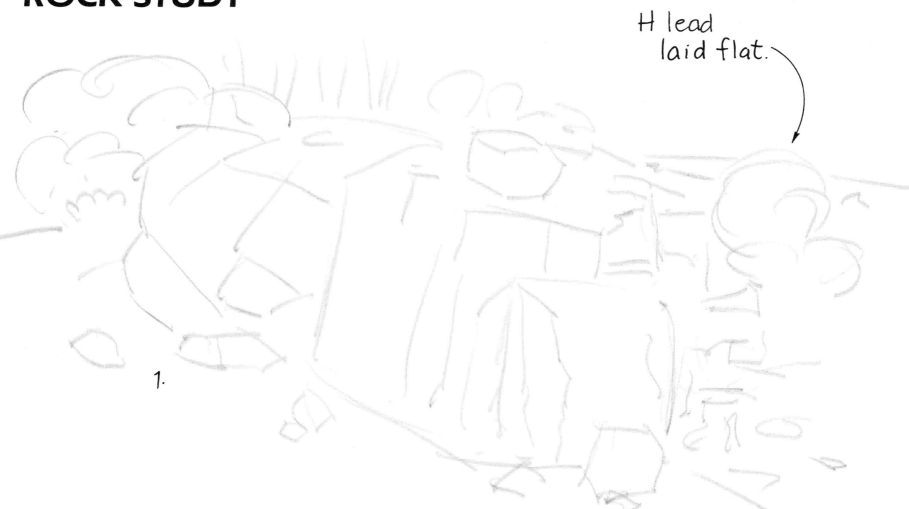

1.

With lead on side of point, feel the shape of the rocks, in their simplest form.

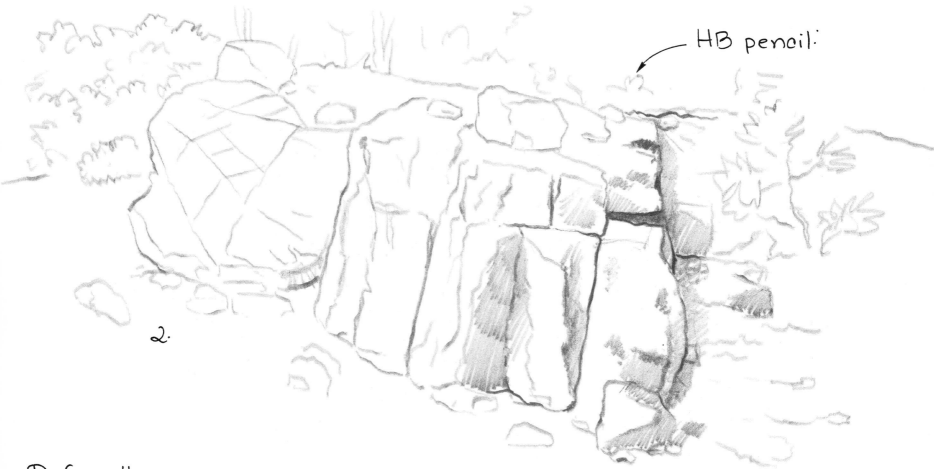

HB pencil.

2.

Define the shapes . . .
Develop the line drawing . . .
Then begin shading by accenting the major darks . . .
Press hard with blunt point.

Use your B pencil
in all point modes.

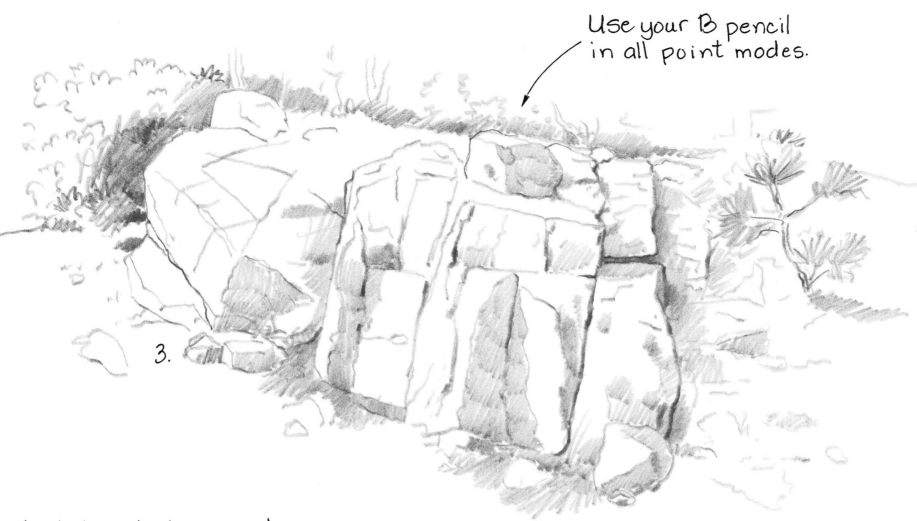

3.

Let the darks spread.
Shade on blunt point for soft tones -- up on sharp point for lines.

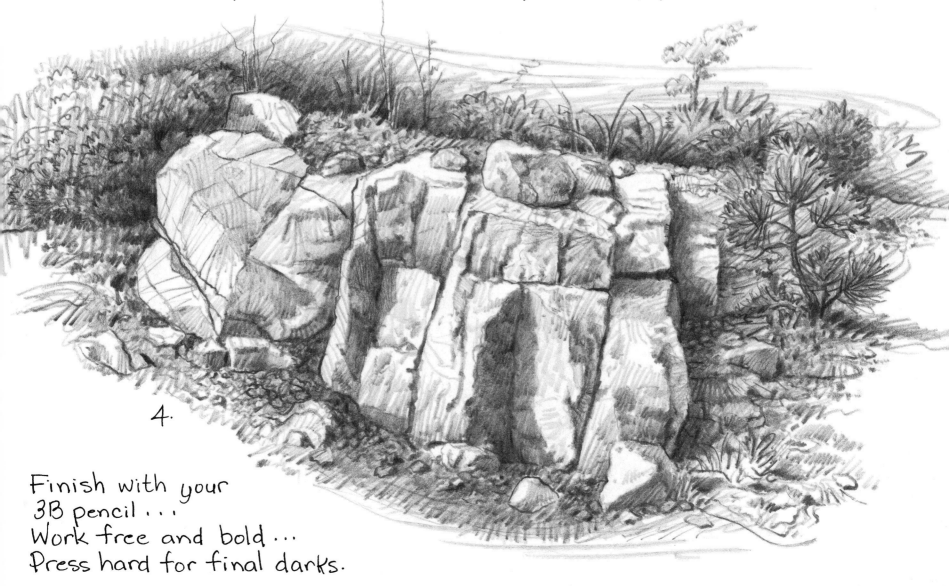

4.

Finish with your
3B pencil . . .
Work free and bold . . .
Press hard for final darks.

FOLIAGE STUDY

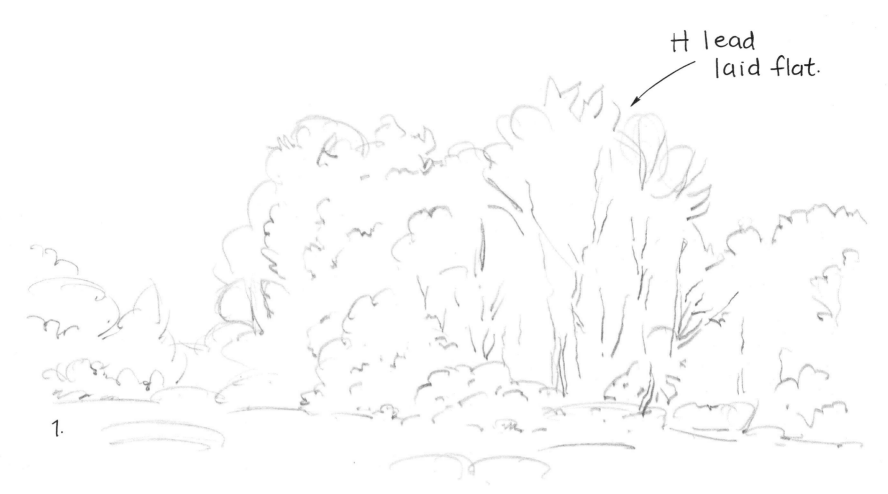

H lead
laid flat.

1.

Sketch the shapes loosely, holding your pencil in the underhand position.

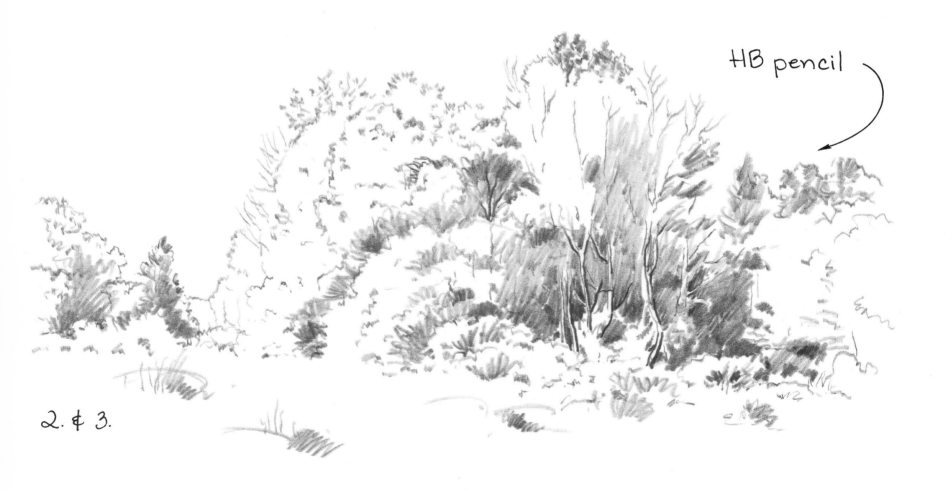

HB pencil

2. & 3.

Develop the line drawing with your HB, and begin shading with the B pencil, concentrating on the shapes of the dark areas.

Use your B and 3B pencils on round and blunt points.

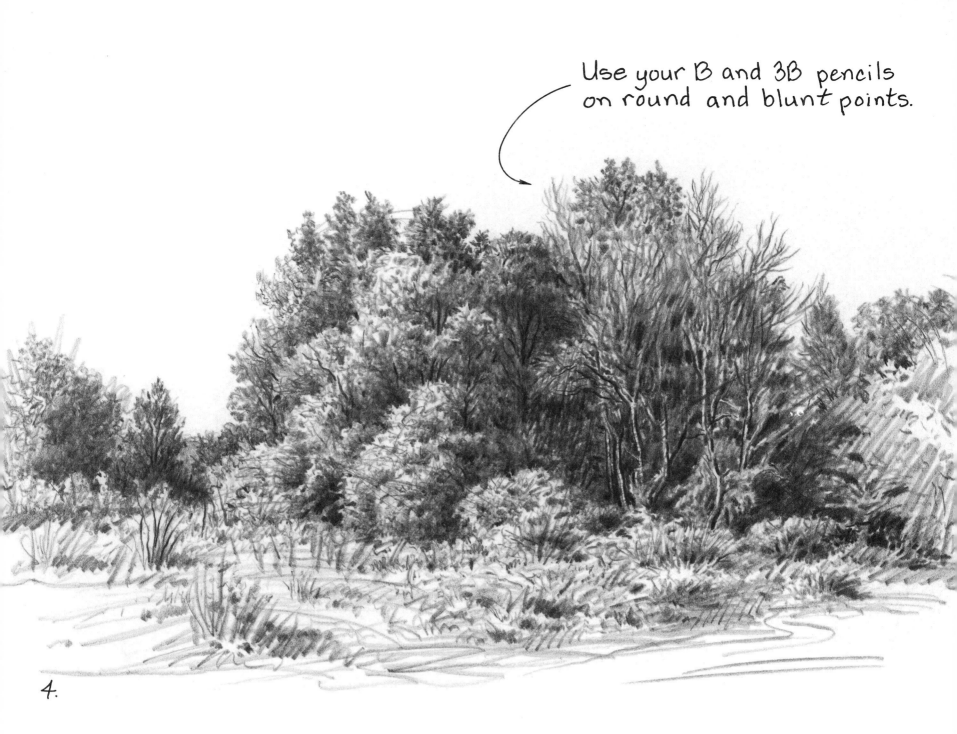

4.

Continue shading with close attention to detail, changing hand positions and point modes as needed. Press hard for tree trunks and indication of leaves.

For a more artistic feel to your work, learn to do masses of foliage and underbrush in brief description, rather than literally copying each leaf.

"Simplify" the subject by squinting your eyes. This eliminates unwanted detail and brings out the highlights. Concentrate on simulating the foliage with bold, expressive strokes. Think in shorthand with the pencil. The B pencil, held under the hand on the side of the point, works well for preliminary shading and developing the character of the foliage. Roll your 3B pencil on the side of the point for a soft indication of distant leaves. Come up on the point and press hard for tree trunks.

In these landscapes it is my aim to emulate the black and whites and the etchings done by the old masters, but with a bolder application.

VICTORIAN CEMETERY

H lead

1.

HB pencil

2.

B pencil

3.

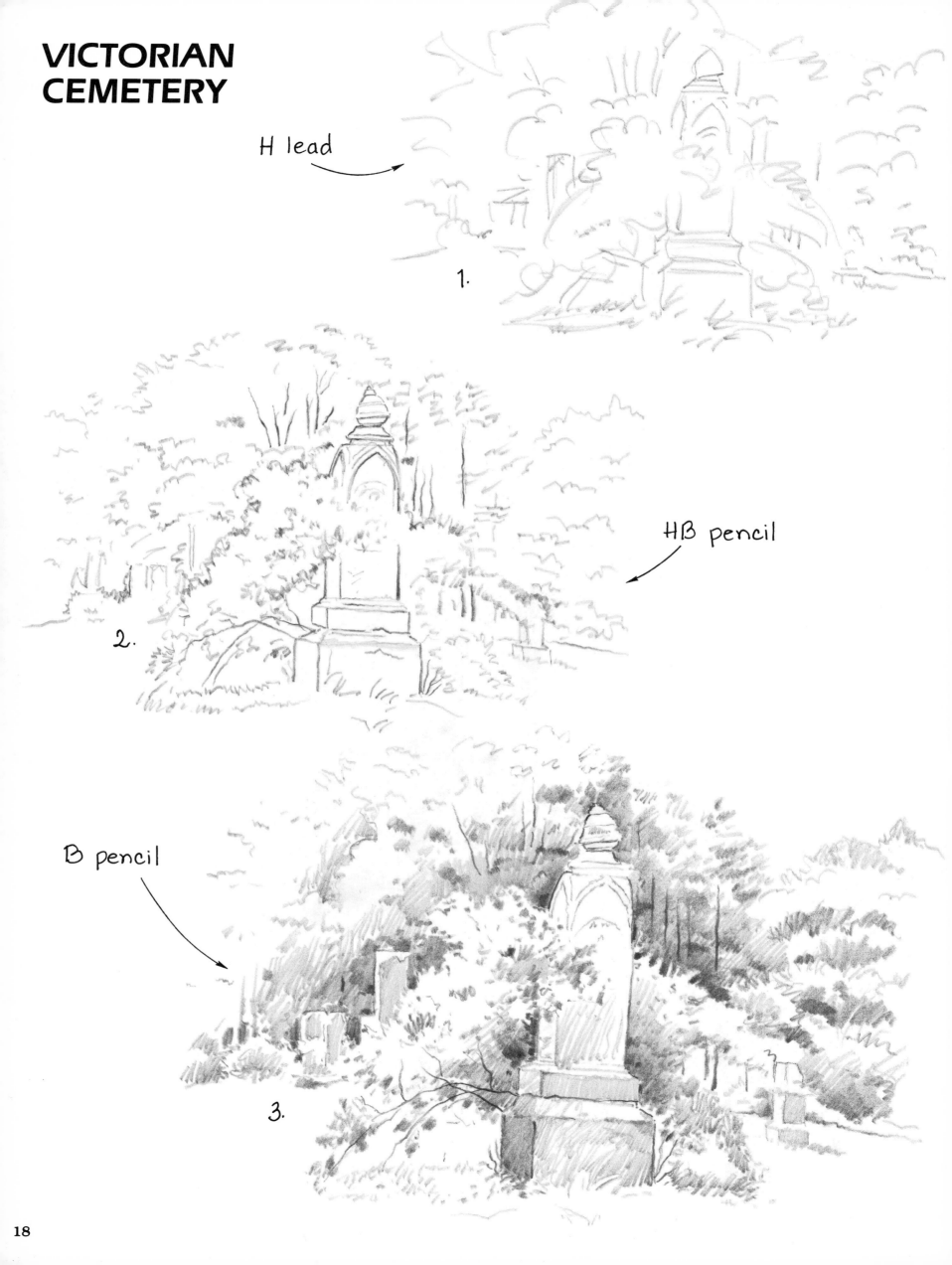

Here is an example of foliage combined with solid form. In this drawing, let the white of the paper come through your strokes on the tombstone to show contrast between the darks and the lights. Strive for variety in textures and play one against the other. For example, the dark leaves of the rosebush and the trees in the background really make the light tombstone "pop."

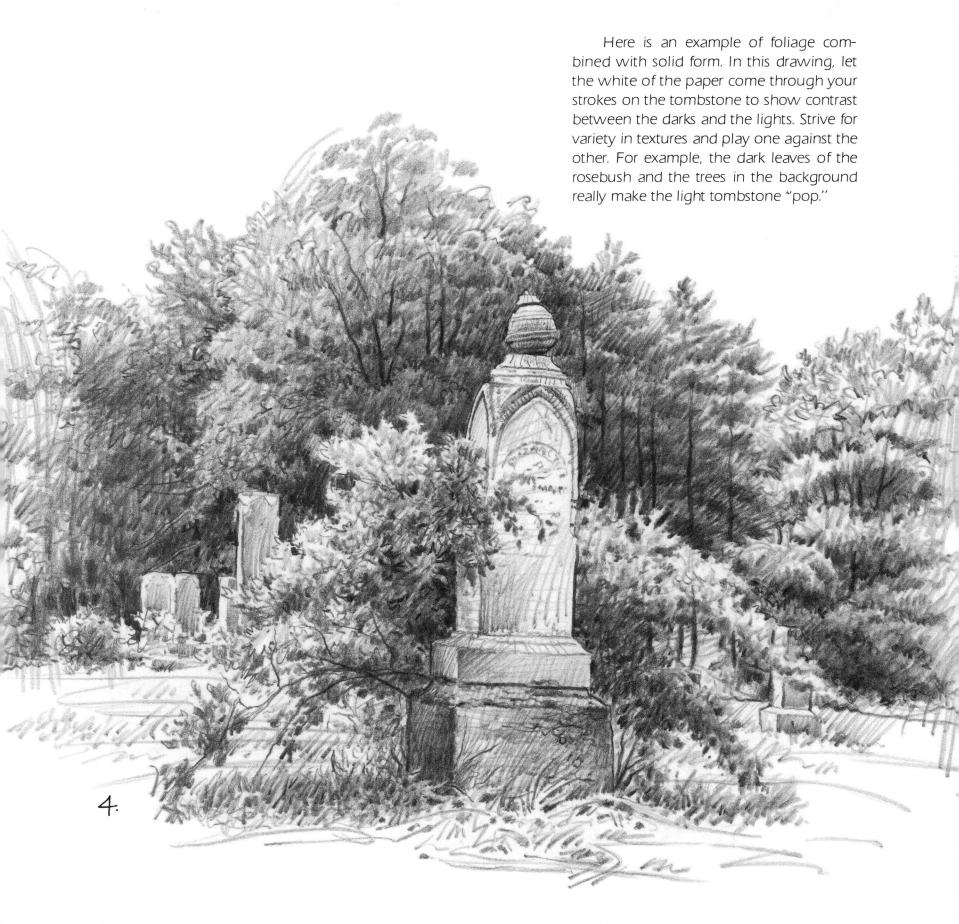

4.

Step One - Feel the shapes lightly with your H lead held under the hand.

Step Two - Identify the shapes more clearly, with your HB pencil.

Step Three - Begin shading with the B pencil used on blunt point.

Step Four - Continue shading with your 3B pencil -- layer over layer, pressing hard for darks.

FOOTHILLS

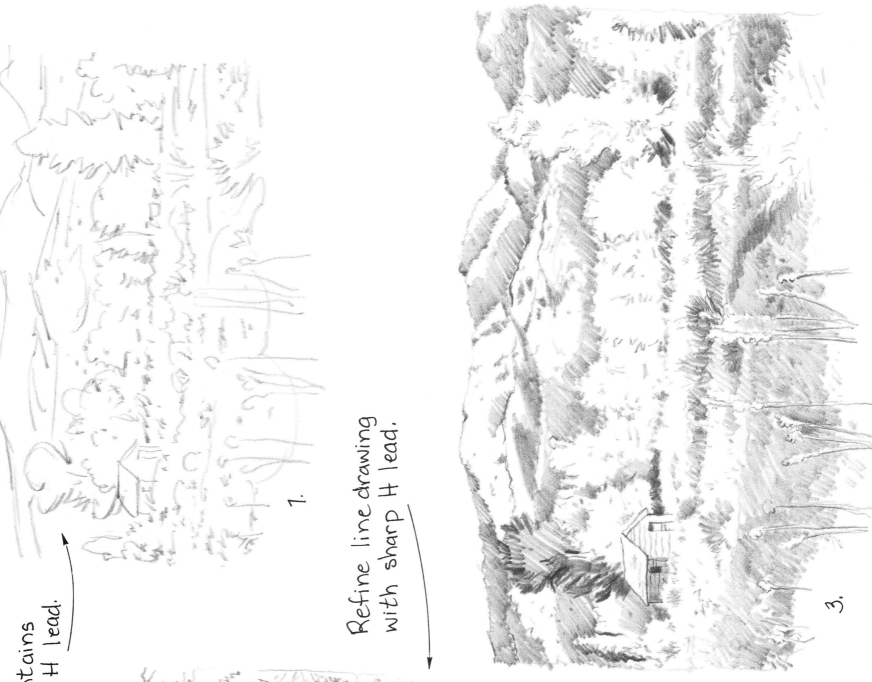

Rough in mountains and trees with H lead.

1.

Refine line drawing with sharp H lead.

2.

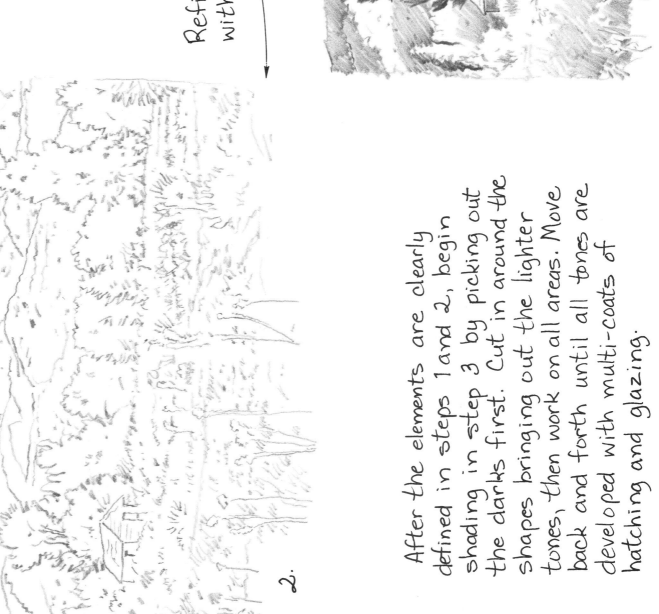

3.

After the elements are clearly defined in steps 1 and 2, begin shading in step 3 by picking out the darks first. Cut in around the shapes bringing out the lighter tones, then work on all areas. Move back and forth until all tones are developed with multi-coats of hatching and glazing.

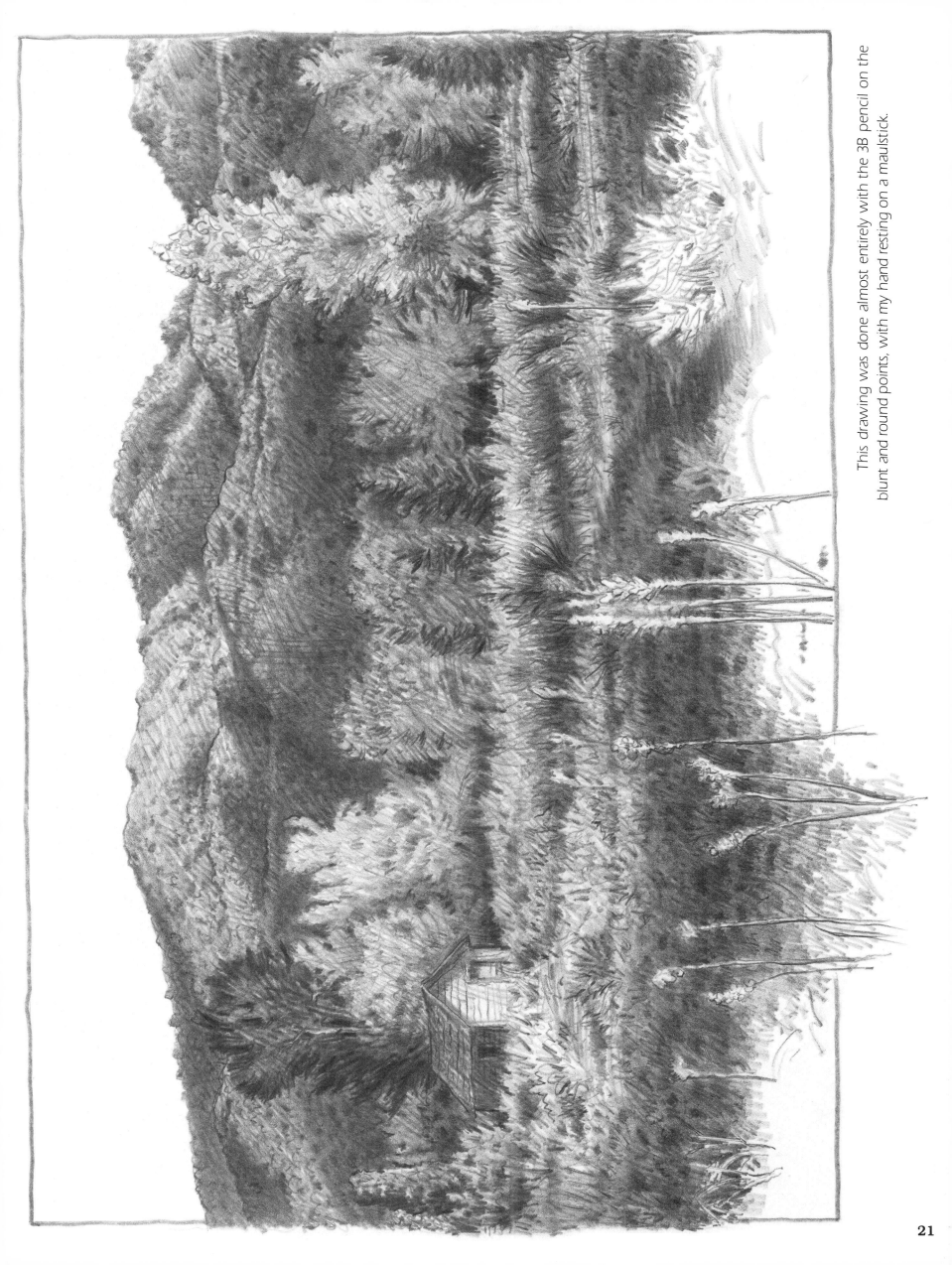

This drawing was done almost entirely with the 3B pencil on the blunt and round points, with my hand resting on a maulstick.

COLORADO CREEK

Sketch shapes with your H lead.

1.

Do more complete line drawing of all elements with your F pencil.

2.

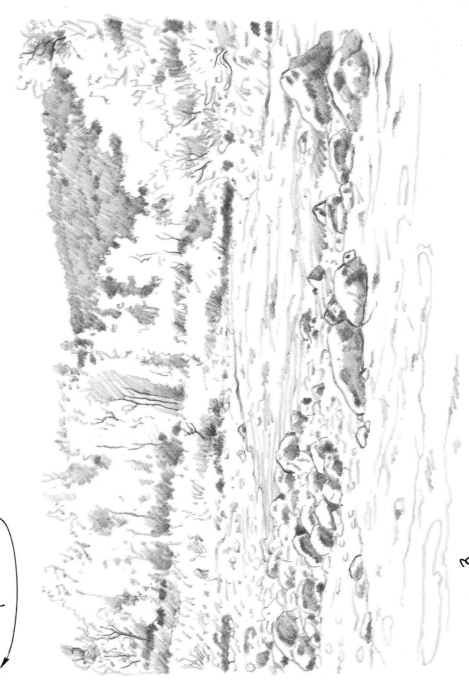

3.

In step 3 establish the darks first with your B pencil cutting around the light areas to make them pop.

In step 4 continue working with your 3B pencil pressing hard with blunt and round points. Alternate layers of hatching and glazing.

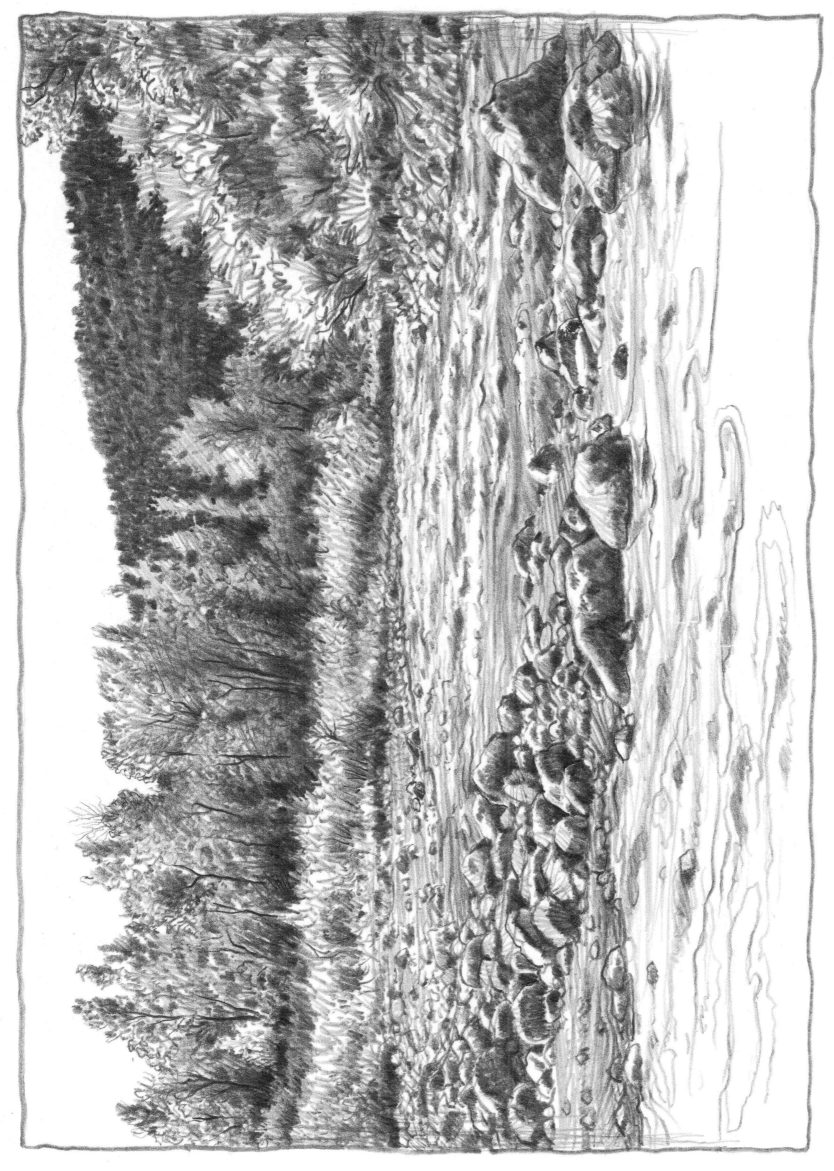

It is surprising how dark and direct you can be when pressing hard on plate finish paper. Work on a maulstick with blunt and round points to achieve depth of tone as seen here. Use a sharp point laid flat for final action strokes.

23

OREGON FARM

Rough in shapes loosely with #1 lead.

1. Refine outline of all the elements with your F pencil on point.

2. Begin to shade with your 1B pencil on the side of the point, varying pressure for special effects.

Step Four – After you have completed the preliminary shading, work very boldly with your 3B pencil on a blunt point, and on the side of a sharp point for sweeping final action strokes.

3.

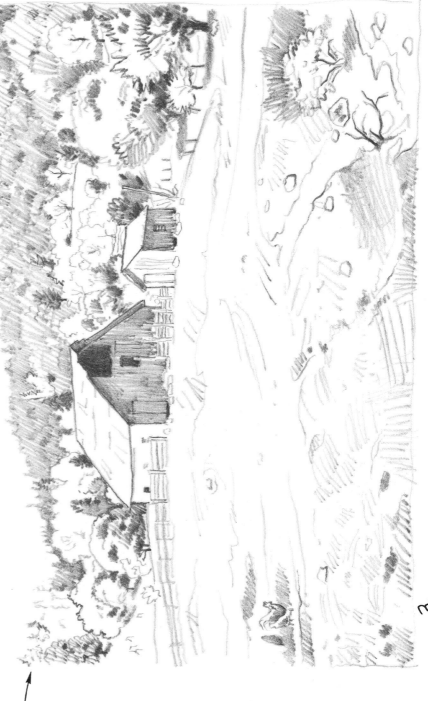

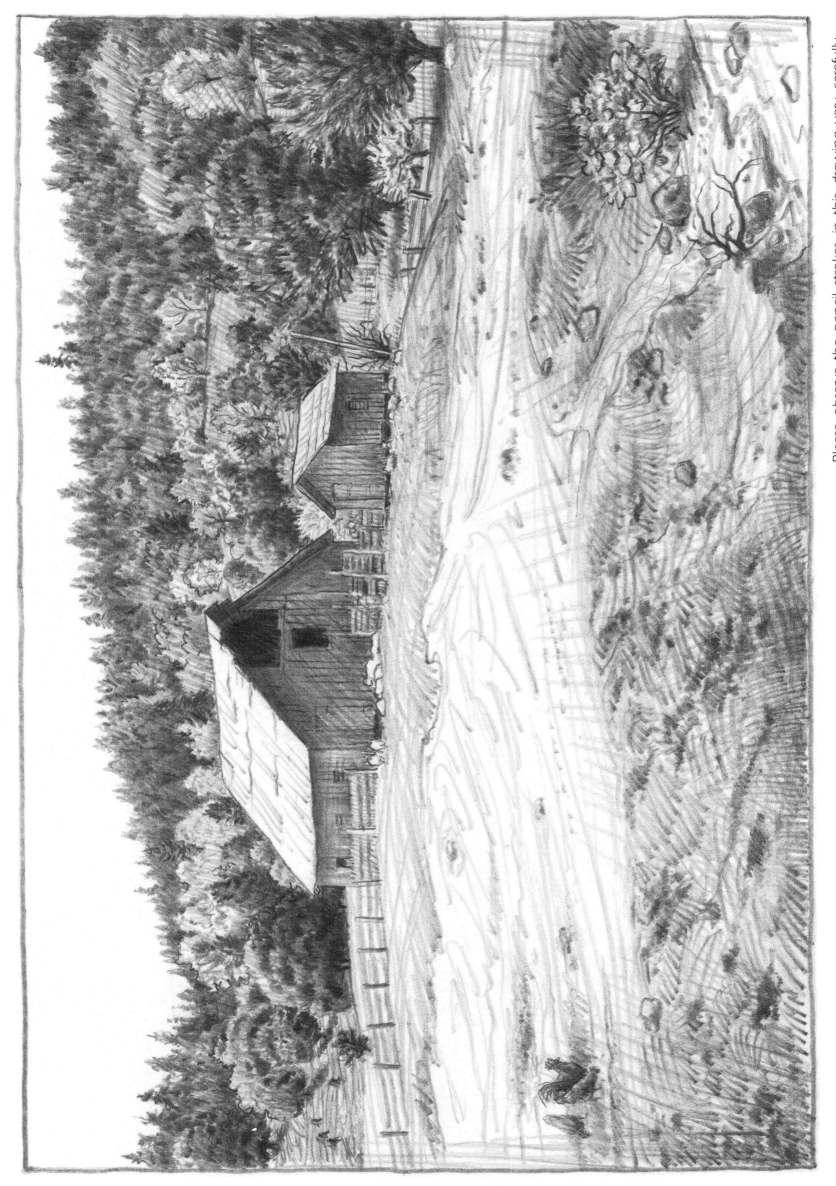

Please observe the pencil strokes in this drawing very carefully. Realize that most of the shading was done with a bold approach using the 3B pencil.

H lead.

1.

HB pencil.

2.

B pencil.

3.

Step One – Feel the shapes with your lead laid flat, using a loose motion.

Step Two – Refine all elements using the point of a well-sharpened pencil.

Step Three – Begin shading with a blunt B pencil worn smooth. Start with the dark areas and then move to the light areas.

Step Four – Continue shading by pressing hard with your 3B pencil.

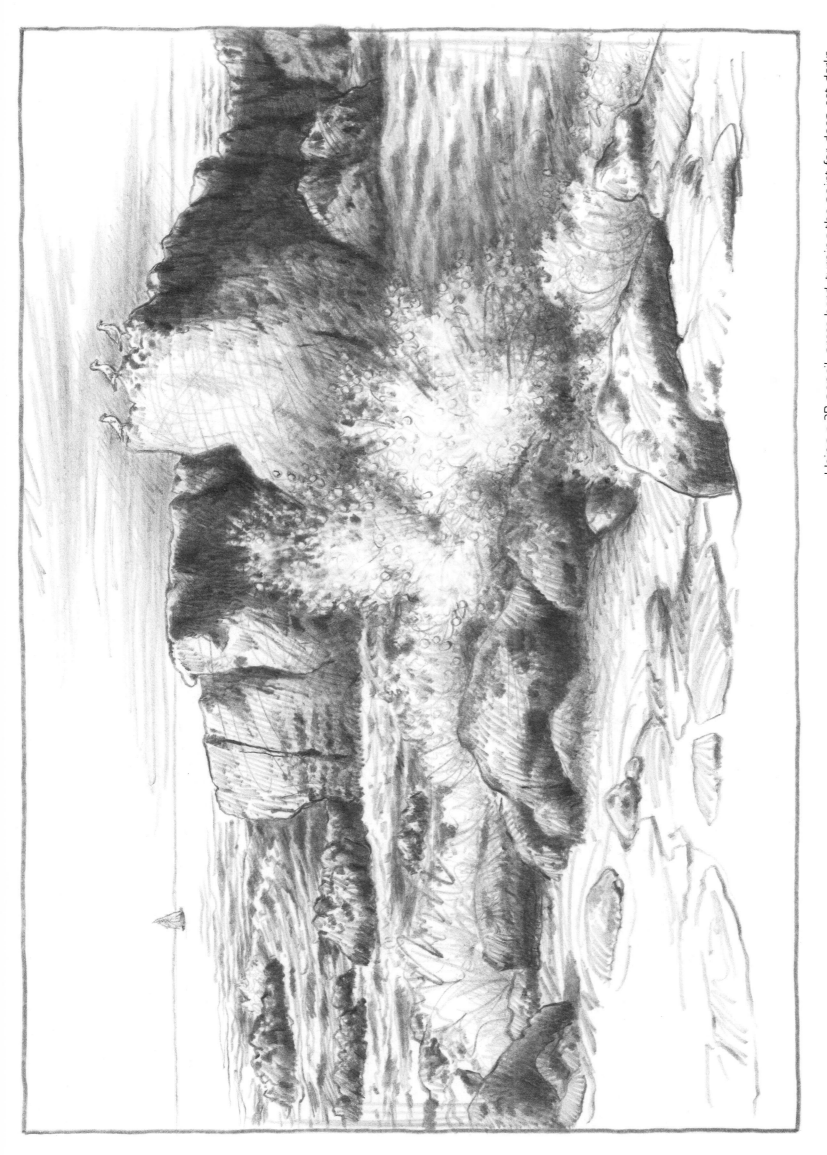

Using a 3B pencil, press hard, turning the point for deep-set darks.
Let the white paper show through for sparkle. Build tones layer on layer
with hatching and glazing.

DESERT JUNIPER

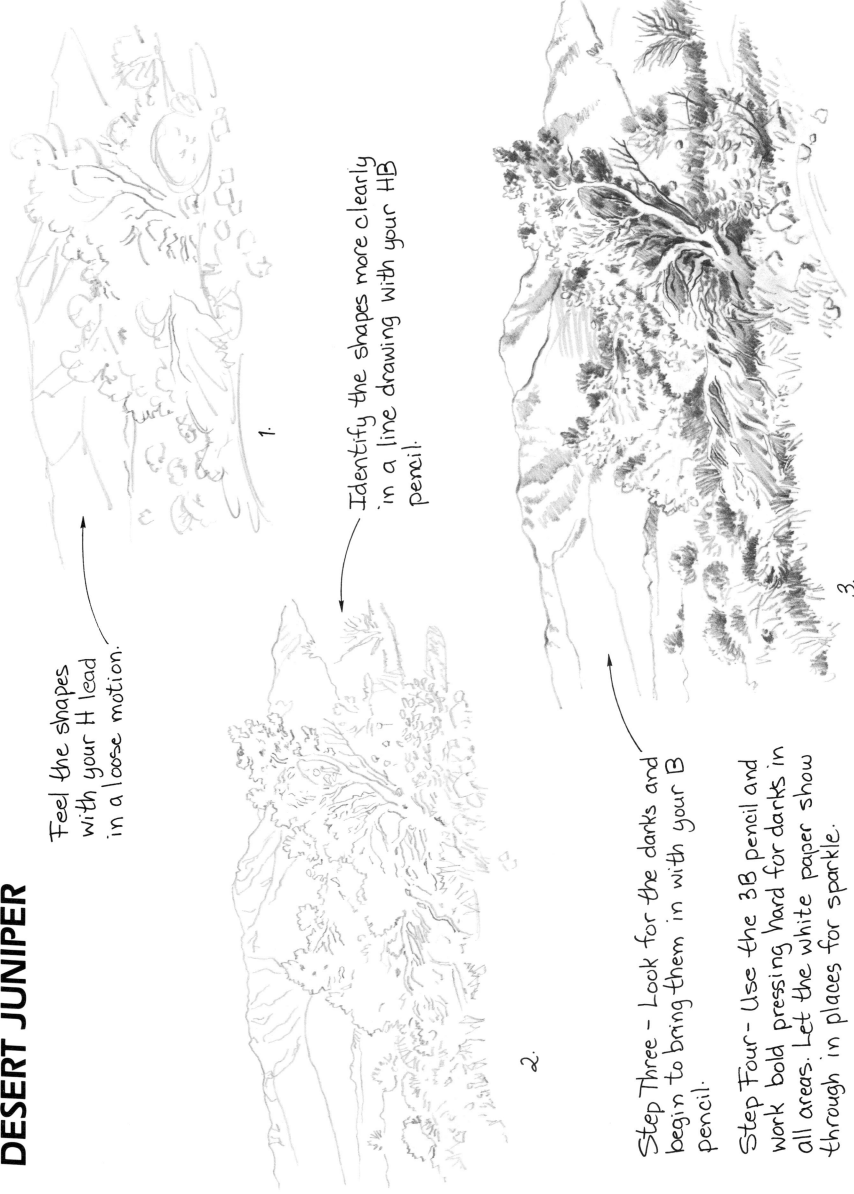

Feel the shapes with your H lead in a loose motion.

1.

Identify the shapes more clearly in a line drawing with your HB pencil.

2.

3.

Step Three — Look for the darks and begin to bring them in with your B pencil.

Step Four — Use the 3B pencil and work bold pressing hard for darks in all areas. Let the white paper show through in places for sparkle.

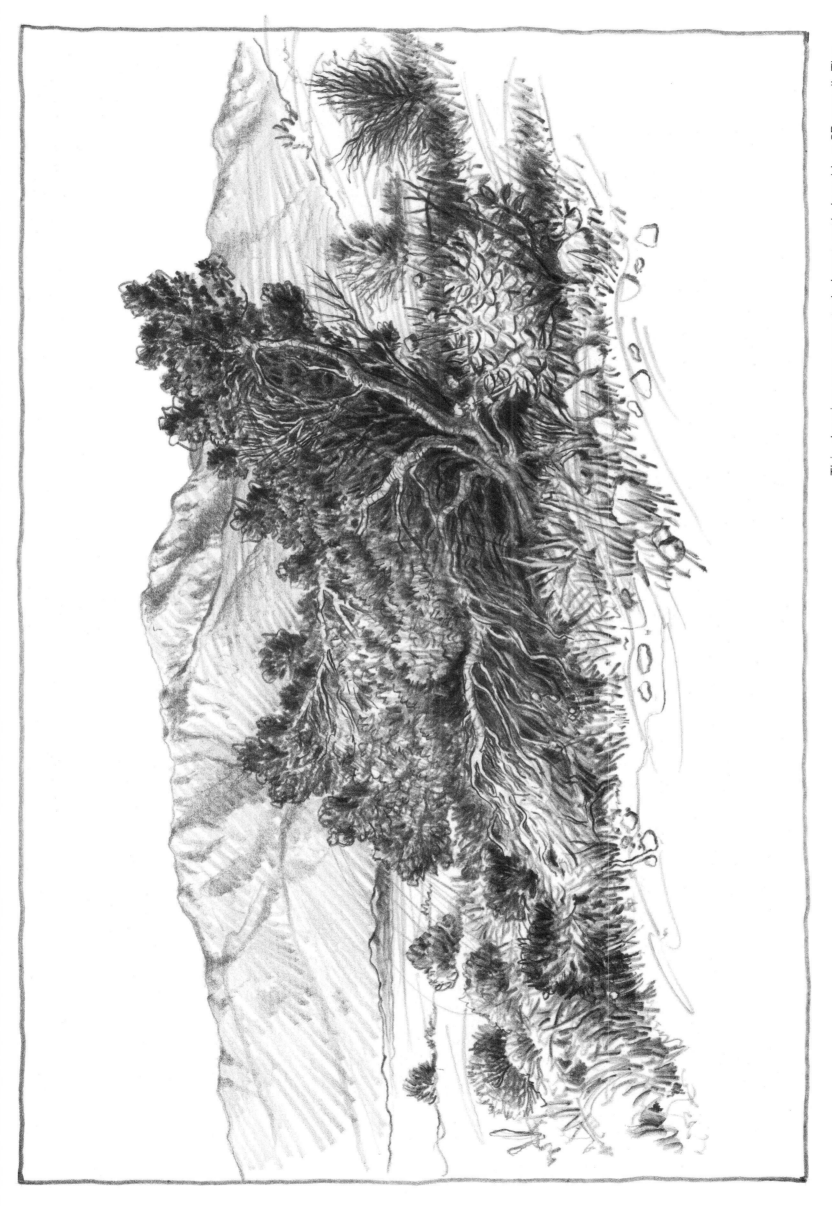

This drawing was executed almost entirely with a 3B pencil. The mountains were rendered in broad strokes with the pencil laid flat. The tree was achieved by pressing hard on blunt and round points for good, deep darks.

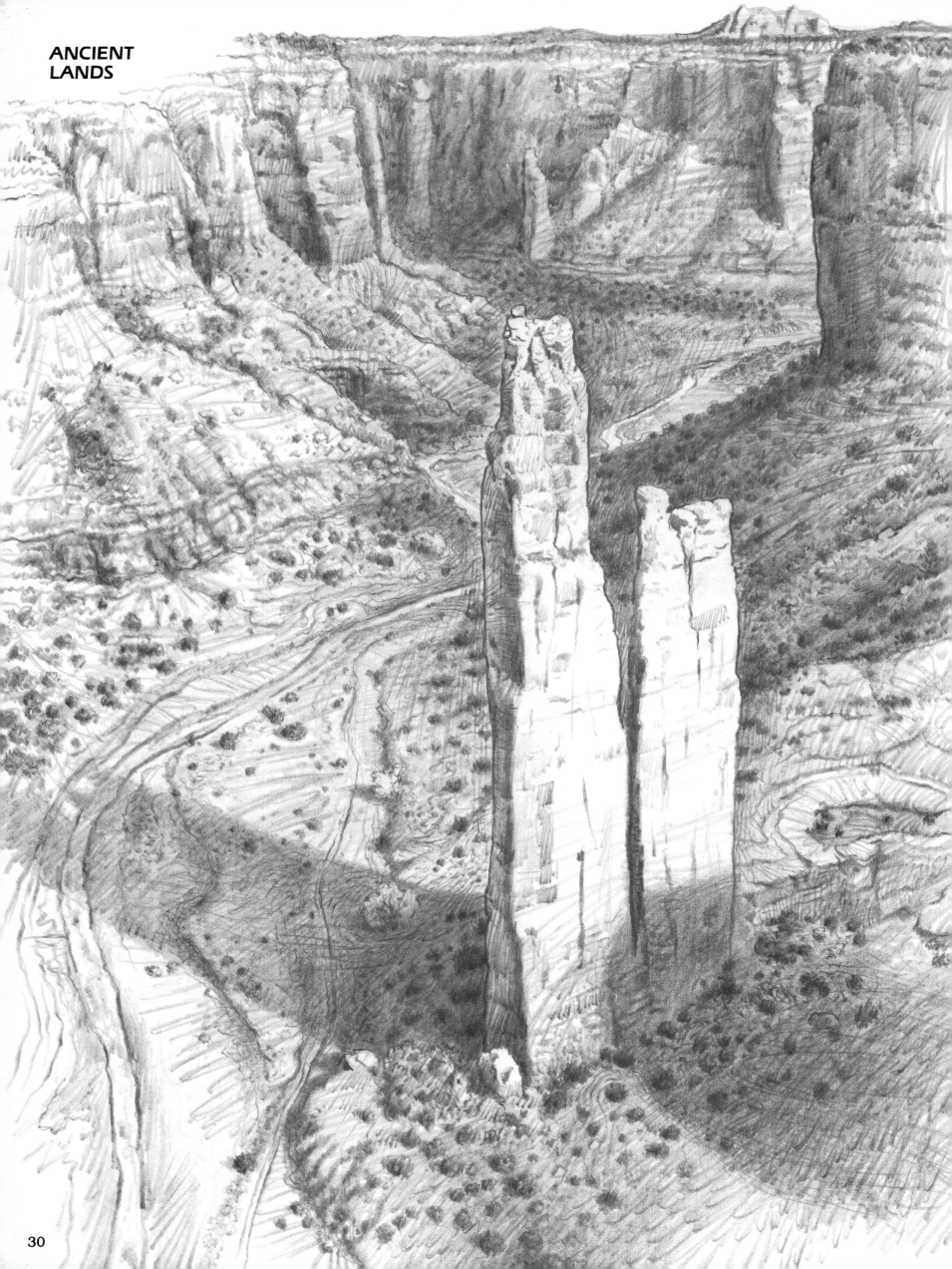

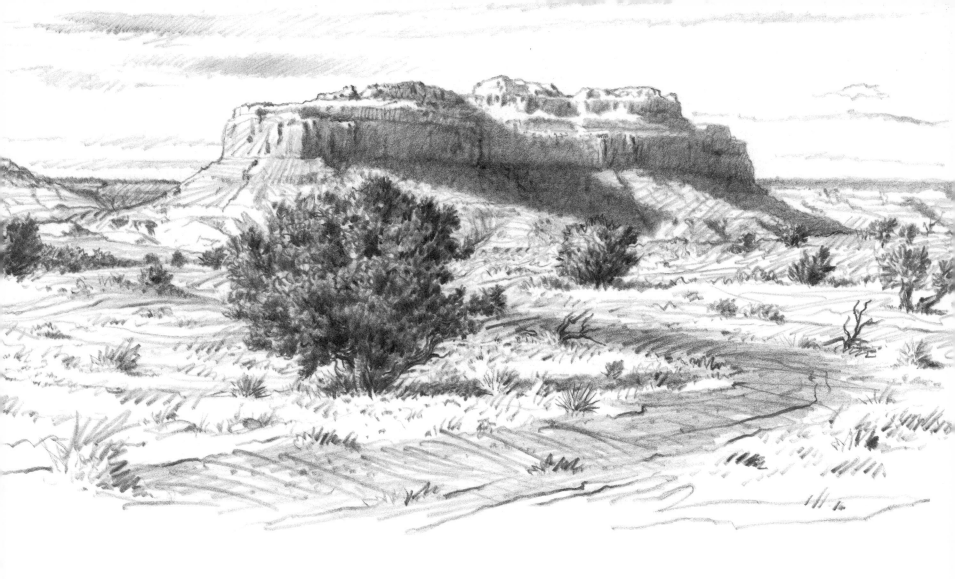

GLOSSARY

BROADSTROKE — A stroke created by laying a long point of lead or pencil on the side.

GLAZE — A transparent film of tone laid in over other strokes; accomplished with a sharp lead or pencil laid flat or with a blunt lead on the point.

HARD EDGE — A crisp outline which makes the subject appear to come forward; produced with a sharp pencil; effective for accents and underlining.

HATCH — A stroke of the pencil on the point to produce short, fine, parallel or crisscross lines.

LINE DRAWING — Outlining the features of an object; produced by the varying pressure on a sharp point and on the side of a point.

MASS TONE — The shading of large areas in a broad back and forth motion, achieved with a sharp lead or pencil laid flat or a blunt lead on the point.

MAULSTICK — A long, light stick used to steady the hand and prevent smudging.

PENCIL POINT MODE — Degree of sharpness.

PENCIL PRESSURE — The personalized degree of firmness in application of pencil that makes your style your own.

ROUGHING IN — Sketching shapes in their simplest forms.

SHADING — Applying multiple layers of tones with pencil strokes and glazing.

SKETCH — A simple study of lights and darks, with little detail and accented with "line drawing" (see above).

SOFT EDGE — An indistinct outline which makes the subject appear to recede; produced with a blunt pencil or lead; effective for showing roundness and depth.

SOFT STROKES — A series of short lines made with a blunt point.

THICK & THIN LINES — Variable widths of line drawing (Step 2 of "Pencil Procedure"); executed by varying pressure on the point and/or by rolling on the side of the lead or pencil.

TONE — The application of a "value" (see below).

TRANSITION — A blending of tone from light to dark.

VALUE — The degree of lightness or darkness. There are nine values in the value scale.

WORKABLE FIXATIVE — A resin solution, available in a spray can, used to "fix" the finished drawing to the paper to prevent smudging.

More Ways To Learn With

WALTER FOSTER Publishing...

*The most recognized name in art publishing
for more than 74 years!*

Disney Learn To Draw Series

The Walt Disney Company© and Walter Foster Publishing have combined their talents to create this wonderful new series of art books for children.

Each book in the **Disney Learn To Draw Series** features a different set of characters and includes step-by-step instructions and illustrations, fun ways to use action lines, tips on outlining and coloring, and hints on how to create different poses and expressions.

Children will be entertained for hours as they practice drawing their favorite Disney characters—and they'll love showing off their very own "masterpieces"!

Paperback, 32 pages, 10-1/4" x 13-3/4"

How To Series

No matter what the medium or the subject matter, we have a book in our **"How To" Series** to fit every artist's needs.

Filled with step-by-step illustrations of techniques for various media, these books address the full art spectrum—pen and ink, pencil, pastel, charcoal, watercolor, acrylic and oil—and they address all skill levels. Their easy-to-follow instructional style takes the beginning artist through the fundamentals of outlining, shading, form and perspective. And, as each lesson builds on the newly developed skill of the preceding lesson, the books move into the more sophisticated rendering techniques sought by the advanced artist.

Paperback, 32 pages, 10-1/4" x 13-3/4"

Blitz Cartoon Series

This new series is designed for people who just can't stop doodling! Bruce Blitz, creator and host of the Emmy-nominated Public Television series, "*Blitz On Cartooning*," believes that anyone with desire and a positive attitude can learn to draw—so he has developed these four new books demonstrating fun and easy methods for turning "doodles" into finished drawings, cartoons and comic strips.

The **Blitz Cartoon Series** is perfect for people of all ages who like to draw, but believe they "can't even draw a straight line."

Paperback, 48 pages, 10-1/4" x 13-3/4"

Collector's Series

Each book in the **Collector's Series** contains a selection of some of the most popular books from our "How To" Series—all combined in a high quality, hardcover edition.

Compiled from many of our bestsellers, each of these books begins with the fundamentals of the particular medium—pencil, watercolor, oil, or animation—then explores the techniques, styles and subjects of the various artists.

The **Collector's Series** was inspired by, and designed for, the serious art enthusiast.

Hardcover, 144 pages, 10-1/4" x 13-3/4"

Beginners Art Series

The **Beginners Art Series** is a great way to introduce children to the wonderful world of art. Designed for ages 6 and up, this popular series helps children develop strong tactile and visual skills while they have a lot of fun! Each book explores a different medium and features exciting projects with simple step-by-step instructions and illustrations.

Paperback, 64 pages, 8-3/8" x 10-7/8"

Artist's Library Series

Serious instruction for serious artists—that's what the **Artist's Library Series** is all about! The books in this series can help both beginning and advanced artists expand their creativity, conquer technical obstacles, and investigate new media. Each book explores the materials and methods of a specific medium and includes step-by-step demonstrations, helpful tips, and comprehensive instructions.

The books of the **Artist's Library Series** are helpful additions to any artist's reference library.

Paperback, 64 pages, 6-1/2" x 9-1/2"

©The Walt Disney Company